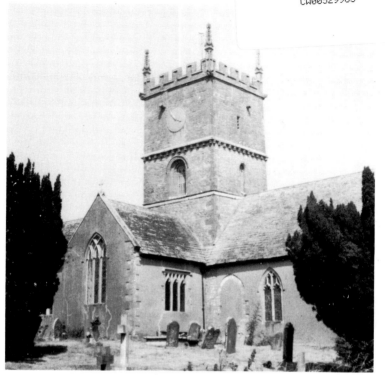

Staunton Church

PARISH CHURCHES OF
THE FOREST OF DEAN

Mike Salter

FOLLY PUBLICATIONS

ACKNOWLEDGEMENTS

The plans, photographs and drawings which appear in this book are the product of fieldwork undertaken by the author in 1981, 1987, 1990 and 2001. Thanks are due to Helen Thomas, who did the driving on the 2001 photographic trip.

The plans in all the churches books in this series (see list inside back cover) are reproduced on a uniform scale of 1:400 and use the same set of hatchings to denote the various periods of work. This volume differs from the other books in the series in that it also contains descriptions and illustrations of churches dating from 1800 up to the present date in addition to earlier buildings.

It is recommended that Ordnance Survey 1:50,000 scale maps are used by those wishing to visit the churches described in this book. Grid references appear after the names and dedications of the churches in the gazetteer.

This book is dedicated to the men and women of Merrydale Morris of Wolverhampton, who performed in the Forest of Dean in July 1990, with grateful thanks for their support and companionship during the period January 1984 to September 1990 when Mike was foreman (dance teacher) of the team.

ABOUT THE AUTHOR

Mike Salter is 48 and has been a professional writer and publisher since he went on the Government Enterprise Allowance Sheme for unemployed people in 1988. He is particularly interested in the planning and layout of medieval buildings and has a huge collection of plans of churches and castles he has measured during tours (mostly by bicycle and motorcycle) throughout all parts of the British Isles since 1968. Wolverhampton born and bred, Mike now lives in an old cottage beside the Malvern Hills. His other interests include walking, maps, railways, board games, morris dancing, and playing percussion instruments and calling dances with a folk group.

This book was originally published in November 1990. This new edition with extra photographs was published in December 2001. Copyright Mike Salter 2001.
Folly Publications, Folly Cottage, 151 West Malvern Rd, Malvern, Worcs, WR14 4AY
Printed by Aspect Design, 89 Newtown Rd, Malvern, Worcs, WR14 2PD

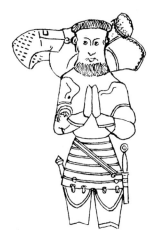

Brass at Newland

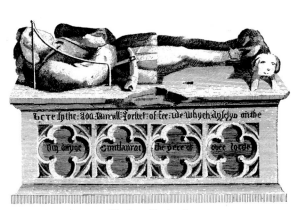

Tomb at Newland

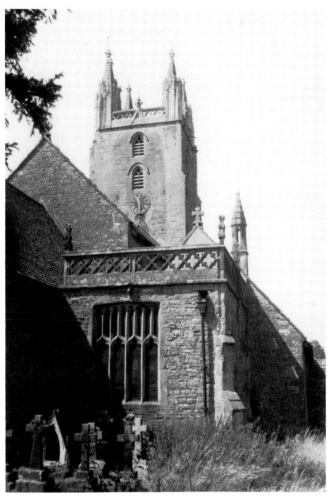

Newland Church

CONTENTS

Inside the front cover is a map of churches in the gazetteer.

Blakeney Church

INTRODUCTION

The few people living in the Forest of Dean in Saxon times seem to have adopted Christianity by the 5th century. In Late Saxon times the area came under the bishopric of Hereford, remaining so until Gloucester Abbey was made a cathedral in 1540. There were perhaps half a dozen churches around the fringe of the Forest plateau by the late 11th century, some or all of them perhaps built of wood. The only surviving feature in any of the churches which definitely predates the early 12th century, however, is the cubical font at Staunton.

The early churches were all rebuilt during the last two thirds of the 12th century and several more were established. These buildings were still sparsely distributed but what remains of them suggests they were above average in size, complexity of layout, and standard of fittings. Lancaut is the only almost unaltered example of the usual humble chapel with two dimly lighted chambers separated by a round arch, the eastern part being the altar space or sanctuary and the western part a nave for laymen to stand it, permanent seating then being unknown. The small windows and doorway were round headed and the floor would originally be beaten earth covered once a year with rushes brought up to the church with appropriate ceremony.

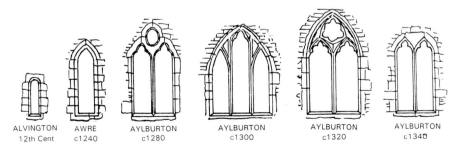

The Development of Windows

By the end of the 12th century the space available for the congregation had been increased at Hewelsfield, English Bicknor, Staunton and St Briavels by adding a lean-to aisle along one or both sides of the nave. These were cruciform churches with a central tower and transepts between the nave and an altar space now somewhat enlarged from the original tiny sanctuary to form a chancel large enough to also contain a choir. The transepts were used to contain side altars. Only at Staunton does the original central tower still survive, but all four churches retain late 12th century arcades with simple round arches. Longhope has a Norman tower at the west end of the nave, the position which was to become the norm for towers in the later medieval period, whilst Ruardean has a fine tympanum depicting St George and the Dragon over the re-set mid 12th century south doorway.

In the 13th century a second aisle was added at St Briavels and Staunton and long new naves and chancels were built at Tidenham and Awre. The latter has an aisle with several lancet windows, tall narrow openings with the pointed arch now in vogue. Later in the century lancets were placed together in pairs, as at Abenhall, and then tracery evolved by piercing the spandrel between the heads of the lights. Eventually geometrical and floral patterns were developed in the window heads. The large churches with long chancels, wide aisles and lofty west towers at Lydney and Newland, the detached tower at Westbury, and the SW corner tower at Mitcheldean are all late 13th century. Work upon the spires continued well into the 14th century. The church itself at Westbury was rebuilt c1300, and so were those at Littledean and Longhope, transepts being added at the latter.

The Perpendicular architectural style with four-centred arches and simpler window tracery types with an emphasis on the vertical first appeared in the Forest of Dean with the comparatively modest new church of the 1360s at Newnham, the splendid tower and spire at Ruardean, and the tower, north aisle and north chapel of c1380-1420 at Littledean. There are 15th century towers at Huntley and Blaisdon and there is important work of the 1460s at Mitcheldean, where an outer north aisle with large windows was added, and the arcades and roofs renewed. Large windows of this period were inserted in several other churches.

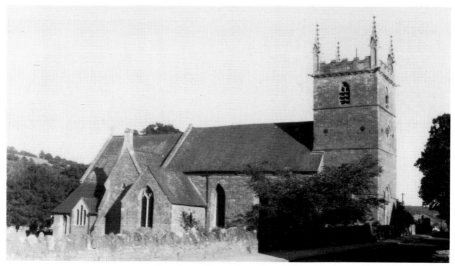

Longhope Church from the north

The only new churches that were not replacements of older structures built in the Forest of Dean between 1300 and 1800 were a 16th century chapel at Bream, and an 18th century church at Blakeney, neither of which have survived. The Industrial Revolution brought about an increase in population and the creation of new settlements requiring churches. Many non-conformist chapels were established in the Forest of Dean during the 18th century. The 19th century saw the construction of a dozen new parish churches and the rebuilding of many of the old ones. Two of the earliest new churches of this period were those at Coleford and Parkend which took an unusual octagonal form. Some of the other new churches have very wide naves, as at Blakeney, Cinderford and Soudley. Good examples of the High Victorian style with marble columns and much decoration are the new churches of Flaxley and Clearwell, and the remodelled medieval churches of Huntley and Newnham.

Although bare to start with, the churches gradually filled up with furnishings, fittings and monuments. From the 14th century onwards chancels were normally closed off by screens which often carried lofts which were used by musicians playing woodwind, brass and string instruments before organs became common in the 19th century. These lofts are known as rood-lofts from the Rood or crucifixion mounted upon them. The staircases in the walls giving access to the lofts often remain long after the lofts themselves have been removed. The lofts were also occasionally used for the performance of religious plays, which were important as a means of communicating ideas to uneducated villagers before sermons became common in the 16th century, along with services and bibles in English instead of Latin. Medieval pulpits do not often survive but two remain in the Forest of Dean churches, including a stone one at Staunton which is reached by a stair serving the roodloft and tower belfry. Several churches have a few late medieval benches, and several have fragments of medieval stained glass. Glass of the 19th and 20th centuries, however, is much more common. Most churches had a lockable chest like that at Awre used to storing valuable plate and vestments. There are fonts remaining from almost every period. The most notable are the Late Norman ones at Newnham and Tidenham, the latter cast in lead. Features from the 17th and 18th centuries mostly are chandeliers, hatchments (boards with coats-of-arms) and galleries. The latter were often removed during Victorian restorations along with high box pews.

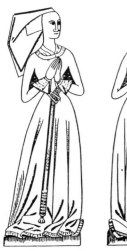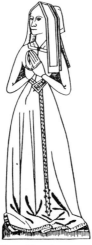

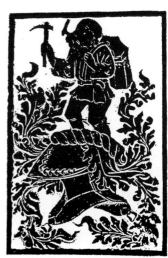

Brasses at Micheldean Church *Miner's Brass at Newland*

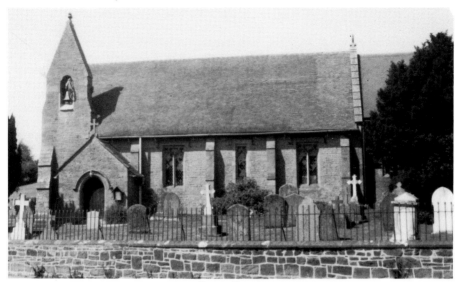

Bream Church

The effigy of a 13th century priest at Newland is the earliest surviving funerary monument in the churches. Newland also has several other tombs and a brass of great interest depicting a Forest of Dean miner. There are three medieval effigies at English Bicknor, and other monuments at St Briavels and Lydney. No tomb chests of the period 1540 - 1700 remain but from the 17th century onwards are many tablets, some of which are adorned with small figures, symbols of death, architectural surrounds, heraldry, etc. Several churchyards have a fine collection of headstones and tomb chests bearing a variety of motifs as well as inscriptions.

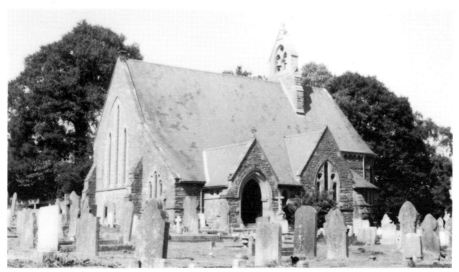

Viney Hill Church

GAZETTEER OF FOREST OF DEAN CHURCHES

ABENHALL *St Michael* SO 671175

There is no real village at Abenhall, and the church, which lies just 1.5km south of Micheldean, is accompanied by just two farmhouses. As originally built in the late 13th century as a chapel-of-ease, the church comprised a modest single chamber with large twin-lancet windows in the north and south walls, a triple lancet west window and an east window of three lights with intersecting tracery. A south aisle with a three bay arcade was added in the early 14th century. This was shortened in the 19th century when a new east wall was built and half of the easternmost arch was blocked up. West of the aisle is a 15th century tower with diagonal buttresses, a polygonal stair turret on the south side, and a shield showing the arms of the free miners on the west side over the blocked doorway. The organ recess and porch are Victorian, whilst the round-headed south doorway looks like reset Norman work, possibly a former priest's doorway or north doorway from Micheldean church.

The 15th century font has quatrefoils in lozenges and shields with emblems of the free miners and smiths, and the arms of the Warwick, Buckingham and Serjeaunt families. The 14th century chancel north window contains contemporary glass fragments, including a figure of St Catherine. The Pyrke family are commemorated by a early 18th century Baroque tablet and a brass to Richard Pyrke, d1609.

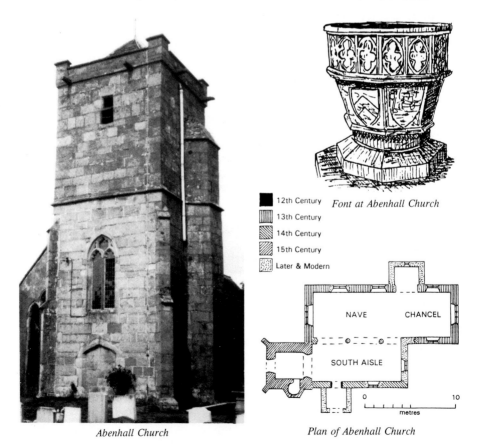

Font at Abenhall Church

■ 12th Century
▥ 13th Century
▨ 14th Century
▧ 15th Century
▦ Later & Modern

NAVE CHANCEL

SOUTH AISLE

Abenhall Church *Plan of Abenhall Church*

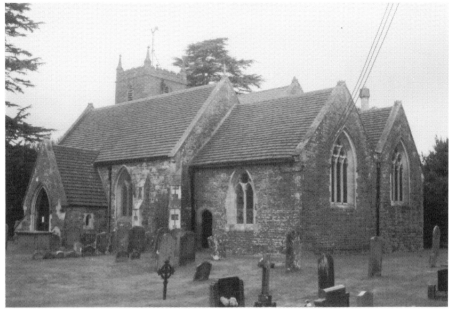

Alvington Church

ALVINGTON *St Andrew*

SO 603008

The chancel north window and the nave SW corner are Norman. They are just sufficient to indicate the size and shape of the church of that period. The west tower added c1300 has an embattled top stage of the 17th or 18th century. The early 14th south aisle is comparatively wide and has a three bay arcade with foliage capitals on the octagonal piers. A squint looks into the chapel to the east. This chapel was rebuilt during the heavy restorations of 1858 and 1890 and other contributions of that period are the south porch, two north vestries, the chancel arch, most of the windows, the font and the reredos. There are tablets to William Clarkson, d1803, Sir Robert Woodrof, d1808, George Watkins, d1832, and Anne Noel, d1851.

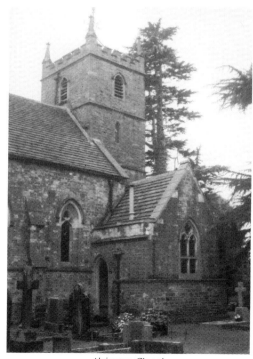

Alvington Church

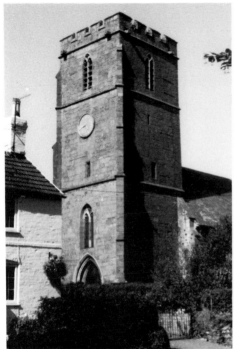

Awre Church

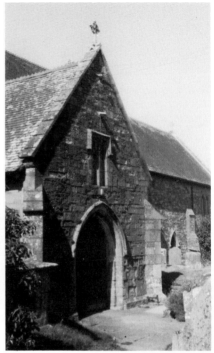

Porch at Awre Church

AWRE *St Andrew* SO 709081

The church lies amongst scattered farms in a loop of the River Severn. It has an embattled 15th century west tower with three stages divided by string courses, diagonal buttresses, and a NE corner staircase turret. The late 14th century south porch seems to have been intended to have had an upper room, either for meetings or as a priest's residence. The long nave and chancel of equal width and the north aisle with a six bay arcade with round piers with moulded capitals are all of c1200-50. Original features are the triple lancet east windows of the chancel and aisle, the north facing single lancets (three in the aisle and one in the chancel), the tomb recess in the aisle, the chancel arch with floriated capitals and the niche above the later medieval south doorway. Other 13th century features are the reset west doorway of the tower and the small east window in the porch.

The south windows and buttresses of the nave are 15th century, as are the restored north windows alternating with the original lancets. The screen dates from c1500 and the staircase up to the former loft is probably an insertion of the same date. The church was comparatively lightly restored in 1875 by Waller and Son. They repaired the boarded wagon roofs of the nave and aisle and provided a new roof over the chancel. The octagonal font with trefoils, quatrefoils and arcading is 15th century. There is a large ancient chest carved out of a single tree trunk, supposedly once used for laying out bodies of those who drowned in the River Severn. The reredos dates from 1892. The monuments in the church include a slate tablet of 1670 and a marble tablet by Henry Healey to Archdeacon Sandiford, d1826, and outside is a good collection of typical Forest of Dean tombstones.

AYLBURTON *St Mary* SO 617019

A plaque on the chancel wall tells us "This chapel was removed from the place where it stood on the hill above nearly without alteration, 1856". So the plan may be basically original, and the five bay arcade of the south aisle, several of the windows and the ogival-headed niche over the south doorway are all of c1290-1340, but the rock-faced outer walling is all typically Victorian. The priest's doorway may be older work of c1200. The tower is entirely 19th century although its simple form with a pyramidal roof makes it look medieval. The north side of the nave is heavily buttressed. The font and stone pulpit are 15th century, and the aisle east window has fragments of medieval glass. There are Royal Arms of George III.

BEACHLEY *St John* ST 550913

This small cruciform church on an isthmus between the Severn and the mouth of the Wye was built in 1833 to a design by Foster and Okeley. It has lancet windows and a rose window with wooden tracery at the west end, with a tiny bellcote above. Set inside are contemporary memorial tablets by Tyley of Bristol. See page 11.

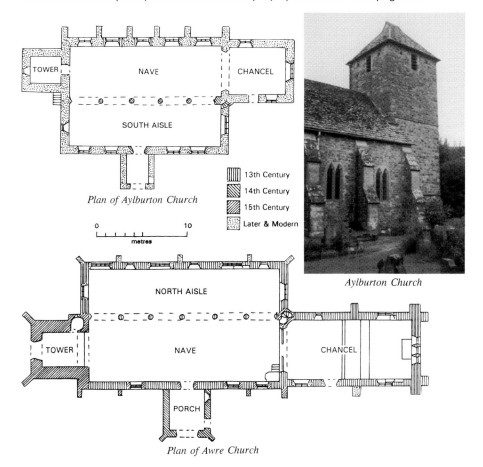

TOWER NAVE CHANCEL

SOUTH AISLE

Plan of Aylburton Church

	13th Century
	14th Century
	15th Century
	Later & Modern

0 10
metres

Aylburton Church

NORTH AISLE

TOWER NAVE CHANCEL

PORCH

Plan of Awre Church

Beachley Church

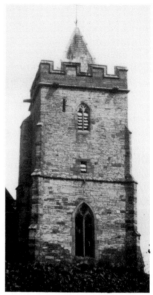

Blaisdon Church

BLAISDON *St Michael* SO 704173

The medieval church was an aisleless 13th century building with a 14th century east window and an embattled 15th century west tower with diagonal buttresses and a short spire. Only the tower, plus some early 16th century pews with a linenfold pattern on them, and a chest dated 1709 with the name John Hayle upon it, survived the rebuilding of the church in 1867-9. It was designed by F.R.Kempson of Hereford, the cost of work, over £2,000, being borne by Henry Crawshay. The church is built of Forest of Dean stone with dressings of Bath stone and apart from the older tower comprises a nave, north aisle, chancel, vestry and south porch. Carved on the capitals of the arcade piers are flowers, leaves, animals and birds. There are several 19th century memorial tablets by Cook of Gloucester. The windows contain stained glass of 1912 by Curtis, Ward and Hughes, and of 1931 by Davies of Bromsgrove.

BLAKENEY *All Saints* SO 673072

This church was established in the early 18th century but c1820 was rebuilt by Samuel Hewlett as a very wide single body with wide lancet windows and a tiny west tower. The apsidal altar space was added during a restoration of 1907. A weathered 15th century stoup serves as the font. See page 4.

BREAM *St James* SO 602055

The present church was built in 1860 to a design by William White. It comprises a chancel with plate tracery in the windows, a nave and north aisle having a four bay arcade with marble columns with big foliage capitals, and an unusually positioned SW corner bellcote. There are king-post and collar-beam roofs, and a vestry was added in 1891. The piscina in the chancel is a relic of the church that existed here in the 16th century. The octagonal font on a slim pillar is probably late 16th century.

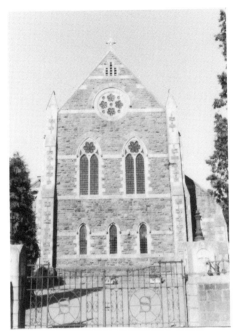

St Stephen's Church, Cinderford

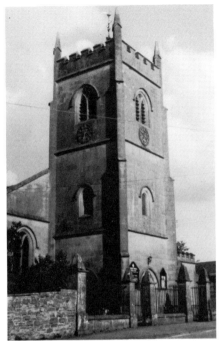

Christchurch

CHRISTCHURCH *Christchurch* SO 704173

This was the first 19th century church erected in the Forest of Dean, built in 1816. It has a nave and wide north aisle and a west tower designed by Richard James with diagonal buttresses and Y-traceried windows. The apsidal chancel with 14th century style windows was added in 1885. Inside is a monument by Johnson to the Reverend Proctor, d1822.

CINDERFORD *St John* SO 653128

Cinderford only gained its own church in 1844, when St John's was built to a design by Edward Blore at the SW corner of the town. It is a rock-faced building with lancet windows lying in a very large graveyard. It comprises a wide nave and chancel with transepts and a turret with an octagonal top surmounted by a spire between the nave and south transept. There is a cast-iron west gallery and a fine 13th century style screen inside. The stained glass in the sanctuary is of 1938, and that in the south transept is of 1946, both being designed by D.B.Taunton of Hardman's. Two north windows have glass by Hugh B.Powell of 1966. The most notable monument is the tablet by Toleman of Bristol to Juliet Crawshay, d1848. See sketch on page 14.

CINDERFORD *St Stephen* SO 658138

The town's growth in the late 19th century prompted the building of a second church dedicated to St Stephen in 1890-3 just south of the town centre. Designed by E.H.Lingen Barker, it has an aisled nave with four bay arcades and a clerestory, and is in the late 13th century style. The organ chamber and vestry were added in 1896.

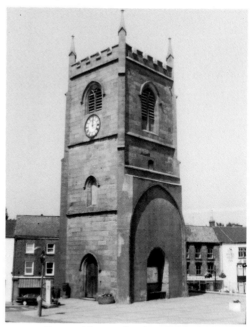

Tower of former church at Coleford

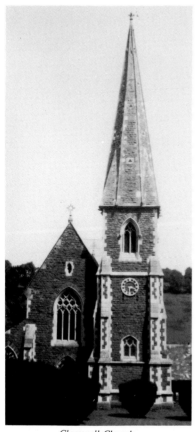

Clearwell Church

St John's Church, Cinderford

CLEARWELL St Peter SO 572080

The present church, designed by John Middleton of Cheltenham, was built in 1866 for Caroline, Countess of Dunraven, owner of the adjacent 18th century mansion called Clearwell Castle. The medieval church, and the building of 1829 designed by G.V.Maddox of Monmouth which replaced it, lay on a different site. The existing church comprises an aisled nave with a tower standing at the west end of the south aisle, a chancel and a south porch. The tower is surmounted by a spire rising to 37m. The outer walls are faced with local sandstone but the dressings are of white Bath stone. The interior has courses of blue and red sandstone alternating with white Bath stone and there are Derbyshire, Italian and Irish marbles with Serpentine in the chancel. There is a great deal of fine sculpture such as the Alpha and Omega panels over the chancel arch, the reredos by Hardman, and the pulpit and font of Caen stone and sandstone. There is stained glass by Hardman, but the south aisle east window is of 1959 by Edward Payne. There are encaustic tiles on the floor.

COLEFORD *St John* SO 575106

Coleford was a chapelry of Newland and only became an independent parish in 1876. In the middle of the town square is a tower which is the sole remnant of a church designed by Richard James built in 1821. It was an octagon similar to that at Parkend. The tower has diagonal buttresses, simple Gothick openings and an embattled parapet with pinnacles. The church was restored in 1862 but was demolished two years after a larger new church designed by F.S.Waller was built in 1880 on a more elevated site to the NW. The new church has a large four bay nave, a two bay chancel and north and south transepts with 13th century style windows. A lofty apsidal sanctuary was added in 1885 by S.Gambier-Parry. Notable features are the war memorial reredos of 1918 in carved oak by Sir Charles Nicholson, and the glass of 1958 by Francis Stephens in the east window.

DRYBROOK *Holy Trinity* SO 648165

This church of 1817 bas a wide nave, short chancel, north and south porches now used as vestries, and an embattled west tower containing what is now the main entrance. It lies alone on a shelf beside the Coleford to Cinderford Road. There is intersecting tracery in the Gothick windows. Inside is a west gallery upon classical columns. The east window glass is of 1922 by Bewsey. There are tablets to Elizabeth Harper, d1837, the Reverend Henry Nicholls, d1867, a noted local historian, and the Reverend Henry Berkin, d1847.

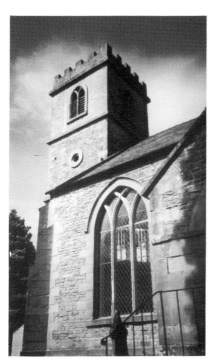

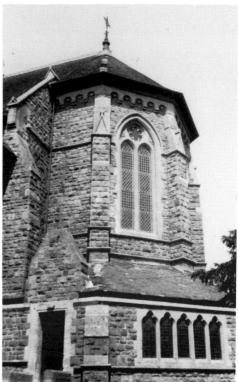

Drybrook Church *Apse of the church at Coleford*

ENGLISH BICKNOR *St Mary* SO 582158

The church lies in the outer bailey of a worn-down motte and bailey castle. The soft sandstone outer walls have been renewed in the 19th century except for the north wall of the 13th century chancel and the west tower, which is also 13th century, although the embattled top stage is 15th century. The interior is more interesting. The four bay north arcade with plain round arches with scallop capitals may go back to the 1140s, the possible date of the castle earthworks. It appears that the church was then cruciform and had, or was intended to have, a central tower. The five bay south arcade is Later Norman work of the 1180s with the piers having scallop capitals with leaves ending in volutes. Also Late Norman is the particularly fine arch at the east end of the north arcade, upon which are chevrons at right angles to the wall and beakheads. Although it lacks a rebate and is unusually wide for a doorway, it seems that this arch originally formed the doorway in the Late Norman south aisle and was reset when the aisle was widened in the later medieval period. The chancel arch is 13th century and the arch to the north chapel looks 18th century, having a keystone.

The Machen chapel on the south side has a screen of c1500 with a boarded dado. Reset in the north chapel is a pillar piscina of c1200. Over the tower arch are the arms of George III. The glass in the east window is of 1908 by Percy Bacon, and there is a chandelier of c1900 imitating 18th century Dutch work. In the north aisle are effigies of the late 13th century priest Ralph de Abenhale wearing a chasuble, and two women in gowns. That with her feet resting on a dog is thought to be Cecilia Muchegros, c1300, and another, with a heart, may be Harwisia de Bures, c1350. There is a tablet of 1644 with cherubs in the chancel, and a portrait bust medallion and weeping child by Symonds to Edward Machen, d1778, in the Machen Chapel.

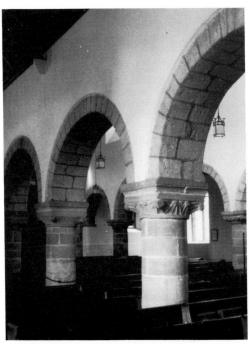
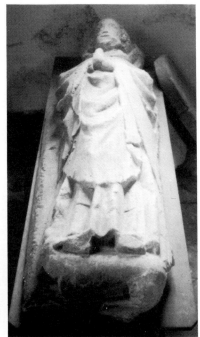

Norman arcades at English Bicknor *Effigy of priest at English Bicknor*

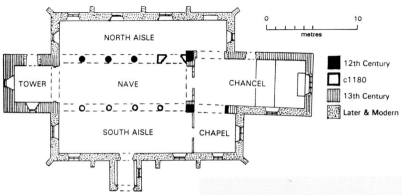

■	12th Century	
□	c1180	
▦	13th Century	
▨	Later & Modern	

Plan of English Bicknor Church

FLAXLEY *St Mary*

SO 688154

This church originated as the gateway chapel of a Cistercian abbey founded c1150. At the Dissolution of the Monasteries in the 1530s the abbey became a mansion and the chapel was raised to status of a parish church. Within it are a monument with cherubs to Abraham Clark, d1683, and tablets to the Crawleys and the Boeveys, a Dutch family who purchased the abbey in 1648. Their most famous member, Catherine Boevey, nee Riches, d1720, also has a monument in Westminster Abbey. The church itself was rebuilt in 1856 to a design by Sir George Gilbert Scott in the late 13th century style. It is of red grit with Forest stone dressings and is very richly decorated inside with carved hood-mould stops, encaustic tiles, and a fine pulpit, font, and reredos all carved by J.Birnie Philip. The church comprises a chancel, a three bay nave, a north aisle with a tower and spire at the west end, and a south porch.

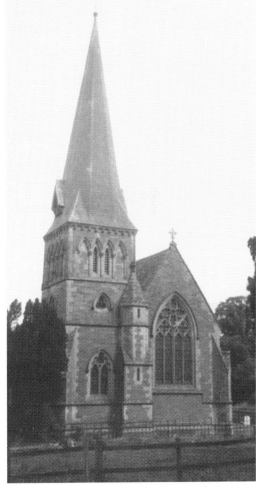

Flaxley Church

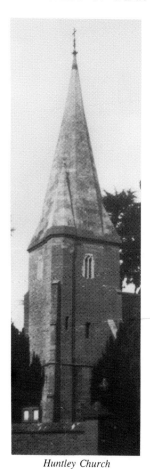

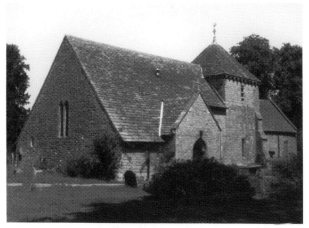

Hewelsfield Church

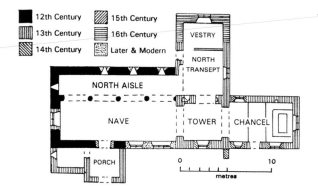

	12th Century		15th Century
	13th Century		16th Century
	14th Century		Later & Modern

VESTRY

NORTH TRANSEPT

NORTH AISLE

NAVE TOWER CHANCEL

PORCH

0 10
metres

Huntley Church

Plan of Hewelsfield Church

HEWELSFIELD *St Mary Magdalene* SO 568022

From the west the church appears to be nearly all roof because the roof over the Norman nave continues down without interruption over the narrow aisle of c1200 on the north side and the small 13th century SW vestry west of the south porch of that period. The aisle has renewed lancet windows and round piers carrying four round arches of two chamfered orders. The inner south doorway is probably late 14th century and the west window is late 13th century. The central tower may be 12th century in origin but has 13th century arches to the east, west and north, the latter with a piscina in the east respond. The tower top has been rebuilt. The north transept was enlarged to the north in 1558, the original late 13th century north window then being reset. The extension is now walled off to form a vestry. The 13th century chancel has an original priest's doorway and east window. The south window is slightly later. Two nave south windows are 19th century. The 13th century font has an octagonal scalloped bowl on a round pedestal. There are tablets with heraldry to Edmund Bond, d1742, and Anne Eddy, d1768.

HUNTLEY *St John the Baptist* SO 714196

Only the 15th century west tower with diagonal buttresses and a SW stair turret survived the rebuilding of what was originally a Norman church in 1863, when a broach-spire was added to the tower. The work was largely paid for by the rector, Daniel Capper, and was designed by S.S.Teulon. Interesting features of the exterior are the Flamboyant tracery of the window in the shallow south transept containing the organ and the stair turret serving the vestry. The rich decoration inside includes alternate bands of red and white stone, red mastic inlays, the fine roof with gilded ribs and bosses over the sanctuary and texts inscribed everywhere. Earp carved the deeply cut flowers on the arcade capitals and the figures of the Four Evangelists on the arcade spandrels. The lectern, pulpit and reredos of alabaster and marble go well with the church but are actually earlier, having been displayed in the Great Exhibition of 1851. There is stained glass by Lavers and Barraud. The nave and aisle windows with biblical scenes drawn in brown lines with coloured shading and grisaille ornamentation were designed by Teulon.

LANCAUT *St James* ST 537965

The ruins of a tiny Norman church just 11.4m long internally lie on a shelf above the Wye in a rather delightful wooded spot 2.5km north of Chepstow. Although originally a chapel-of-ease, it had attained full parochial status by the 13th century. The church is accessible easily enough on foot but there is no road to it and since it lay some distance from any settlement it was finally abandoned in the 1860s. The chancel of c1180-1200 has been added to an almost square earlier nave. The east window embrasure has a roll-moulding around it. The plain mullioned window, piscina and priest's doorway in the chancel south wall are 14th century insertions. The stones of the nave doorway arch now lie on the ground within it. Two pointed openings of uncertain date in the west gable once contained bells. From this church has come the late 12th century lead font now set up in the Lady Chapel at Gloucester Cathedral. The bowl has an arcade in low relief with alternating figures and scrolls. See p20-21.

Huntley Church

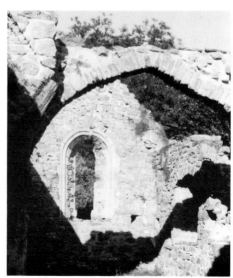

Lancaut Church

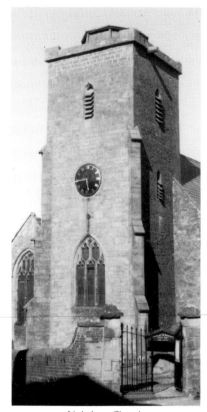

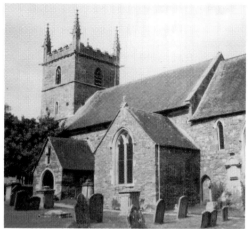

Longhope Church

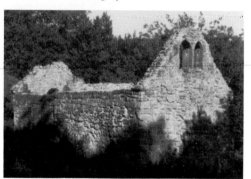

Lancaut Church

Littledean Church

LITTLEDEAN *St Ethelbert* SO 673136

All that remains of the Norman church are the responds of the chancel arch. The nave and chancel were both rebuilt c1300. The diagonally buttressed west tower and the north aisle with a four bay arcade were added at the end of the 14th century, and the Brayne chapel north of the chancel was added c1411. It and the north aisle have two-light square-headed windows of the same type, some of them containing fragments of original stained glass. The tower has the stump of a spire which was destroyed by a gale in 1894. There are original wagon roofs with ribs and bosses in the nave and chancel. At the SE corner of the nave is the staircase of the former rood-loft. The outer entrance of the 14th century porch has been blocked and the room converted into a vestry. Upon it are mass sundials. The church has suffered only minimal 19th century restoration.

The font has an 18th century bowl with a 17th century base. In a case is a pair of tunicles of c1500 sewn together to make an pall or altar cloth. In the chapel is a 17th century table. The chancel contains a tablet by T.Rickets of Gloucester to Thomas Pyrke, d1752, and there is another Pyrke monument set high up in the nave. There are several noteworthy tomb stones in the churchyard. One records a policeman killed whilst apprehending poachers and another recalls the death of four youths in a pit accident.

LONGHOPE *All Saints* SO 684198

Despite the fairly heavy restoration in the 1860s by A.W.Maberley, when the north vestries were added and the renewed east window provided with stained glass by Claydon and Bell, the church has considerable medieval interest. The lower parts of the four stage west tower are Late Norman and have mid-wall pilaster buttresses and one original window. Remains of another Norman window in the nave north wall indicate that the wide nave is essentially Norman too. A recess in the north transept east wall contains an effigy of a priest of c1300 in eucharistic vestments. Perhaps it was he who sponsored the rebuilding of the chancel to match the width of the nave, the addition of narrow transepts, and provision of a new tower arch. The porch and several windows are early 14th century and the embattled top stage of the tower with corner pinnacles is probably late 14th century. One lancet and the priest's doorway in the chancel south wall are 13th century, and there is a 15th century window there also, whilst the chancel arch is 19th century. There are Royal Arms of William III, early 19th century commandment boards, and a painted tablet with a flat obelisk and urn to Josiah Bright, d1777. In the churchyard is a mortar which served as the font from the 1660s to the 1860s, when a new font was provided inside.

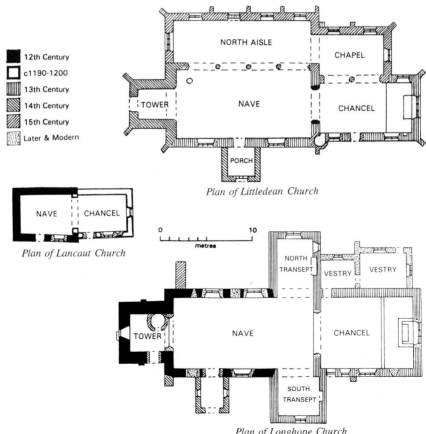

12th Century
c1190-1200
13th Century
14th Century
15th Century
Later & Modern

NORTH AISLE

CHAPEL

TOWER NAVE CHANCEL

PORCH

Plan of Littledean Church

NAVE CHANCEL

Plan of Lancaut Church

0 10
metres

NORTH TRANSEPT VESTRY VESTRY

TOWER NAVE CHANCEL

SOUTH TRANSEPT

Plan of Longhope Church

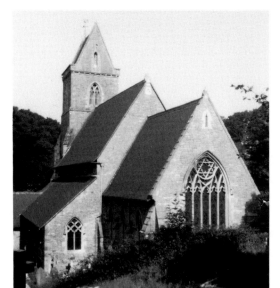

Lydbrook Church

LYDBROOK *Holy Jesus*

SO 605517

The church nestles against a steep hillside. It was built in 1851 to a 14th century style design by Henry Woodyer, and comprises a fully aisled nave with a low clerestory, a west tower with a saddle-back roof, a south porch, and a chancel. The roofs have a complex pattern of wind-braces and there are scissor-beams in the chancel. The window tracery is mostly in the Geometrical style. The church was restored in 1904 by M.H.Medland, and an organ chamber was added in 1913 by A.W.Pearson.

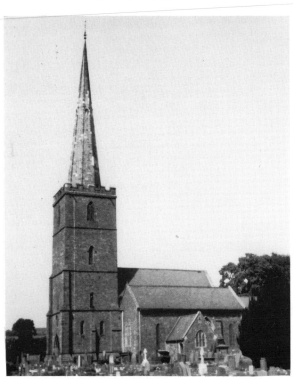

Lydney Church

Lydney Church

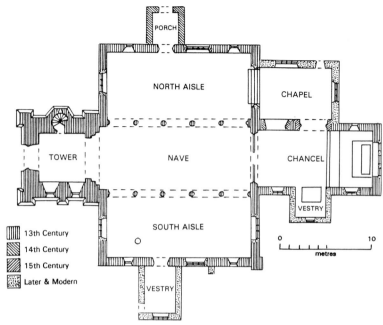

Plan of Lydney Church

LYDNEY *St Mary* SO 634025

The west tower, the aisled nave with five bay arcades, and the chancel are all 13th century. They form a building of considerable size, mainly owing to the great width of the aisles, perhaps a result of patronage by the Beauchamp and Talbot families, who held manors in Lydney. However, the exterior has been heavily restored and is not of much interest or beauty except for the splendid tower. This part has clasping corner buttresses, a polygonal stair turret on the north side, and a west doorway with orders of sunk-quadrant mouldings suggesting a date not earlier than c1280, whilst the spire may not have been completed until the 1340s. The north chapel was probably added to serve the chantry of the Holy Cross endowed in 1375 by John and Julia Chardborough and the north porch may have been added at about the same time. The chapel was rebuilt in the 1850s (when the spire was also restored) to serve as a choir vestry and organ space, but it was made into a chapel again in 1940. There are fine old wagon roofs over the nave and aisles.

Before the Victorian restoration the church was said to be packed with high pews whilst a painting shows probably made soon afterwards shows it almost devoid of woodwork except for a high pulpit. Over the north chapel arch are the arms of the Wynter family. The font is 15th century. There are Royal Arms of William III and Mary II, and a hatchment and a banner of Lord Bledisloe. Several windows have glass by Hardman, whilst the east windows have glass of 1946 by Smith, including a scene of the Franz Josef Glacier in New Zealand. Another window has glass of 1938 by Joseph Bell. Although inscribed with the year 1630, the female effigy holding a heart is 14th century. Poole Bathurst, d1792, is commemorated by a mourning female by T.King of Bath, and there is a tablet by Paty of Bristol to Mrs Brass, d1793. Outside is a fine collection of interesting churchyard tombstones.

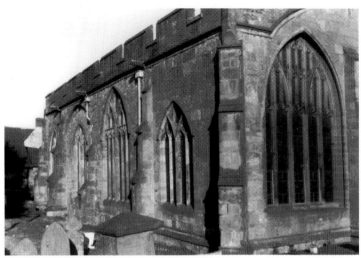

North side of Mitcheldean Church

MITCHELDEAN *St Michael* SO 664186

Of the original 12th or 13th century nave only the west wall still remains. The tower at the SW corner and the porch south of it are late 13th century. There must have been a south aisle by that period, although the present aisle is early 14th century. A north aisle was then added, along with the top two stages of the tower and a lofty spire which was rebuilt in 1760 by Nathaniel Wilkinson. In the 1460s the church was remodelled, being provided with new arcades, of three bays on the south side and four on the north, where a wide outer aisle with its own four bay arcade was added, possibly in two stages, since the north wall shows iregularities. The fine roofs of this period have ribs, plastered panels, bosses and angels holding shields. On the south side a stair turret was added to give access up to a loft upon a screen which ran across the whole width of the building. The stair continues down before floor level to give access to a bone-hole below the south aisle. The screen has unfortunately gone, the present short screen being 19th century, as is the east bay of the chancel it closed off, and the vestry north of it. A 15th century painting of the Last Judgment with scenes of the Life of Christ fills the space between the screen and the roof.

The huge west windows of the nave and outer north aisle contain early 20th century glass. There are fragments of medieval glass in the north windows, whilst the south aisle has one stained glass window by Kempe, and the east window has glass of 1968 by John Hayward. In front of the latter is a huge reredos erected in 1911 with life-sized figures by W.G.Storr-Barber. Part of the font bowl is Norman, the rest being 19th century. The 15th century wooden pulpit is no longer in use, and the seat from it is fixed on the south arcade west respond. On the nave south wall are brasses of two wives of Thomas Baynham, Margaret, d1477, in a butterfly head-dress, and Alice, d1518, in a dog-kennel head-dress. There is a Baroque tablet in the south aisle to Elizabeth Holmes, d1758, and in the chancel is an 18th century tablet by Bryan of Gloucester. In the outer north aisle are monuments to Edward Sarjeaunt, d1698, and his wife Anne, d1653, William Lane, d1748 and his wife Elizabeth, d1753, and John Stephens, d1767 and his wife Tracy, d1773.

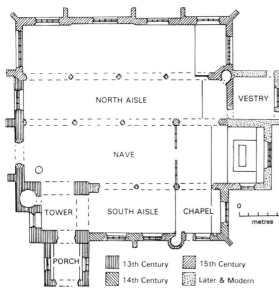

NORTH AISLE

VESTRY

NAVE

TOWER

SOUTH AISLE

CHAPEL

0 5
metres

PORCH

||||| 13th Century /// 15th Century

\\\ 14th Century :::: Later & Modern

Plan of Mitcheldean Church

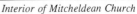

Interior of Mitcheldean Church

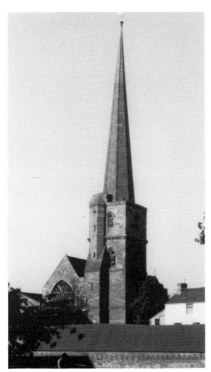

Mitcheldean Church

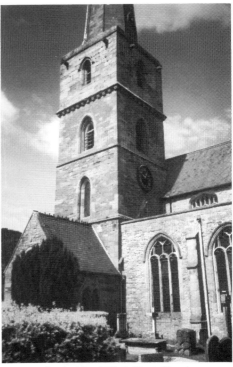

South side of Mitcheldean Church

NEWLAND *All Saints* SO 553096

This church is thought to have been founded in the time of Rector Robert Wakering (1215-37). A later rector, Walter Giffard, went on to become Archbishop of York. Most of the present building, however, dates from c1280-1300, when Edward I's historian John of London, a monk of Westminster Abbey, was rector. It is the largest church in the Forest of Dean and is nicknamed the "Cathedral of the Forest". Originally it comprised a west tower, a nave with five bay arcades opening into very wide aisles, a south porch, a chancel and a south chapel forming a continuation of the aisle. Edward I added the small chapel east of the porch to contain the chantry of King Edward's Service founded in 1305, and the north chapel was added to serve the chantry of Our Lady's Service founded by John Chinn, d1416.

In 1426 the Bishop of Hereford struck out at the practice of trading in the spacious churchyard. This now forms a close surrounded by 17th and 18th century houses. The church was on the verge of ruin by 1861, when it was restored by William White. He provided a new east window with glass by Claydon and Bell, a new clerestory, plus a few buttresses. The south chapel east window and the tower west window are unrestored work of c1300 and the north chapel also has an original east window. The tower has clasping corner buttresses with support diagonal buttresses above. The top storey and the four spired corner pinnacles with blank panelling, plus the stair turret with its plain spire are probably of c1360-80.

The fittings of interest include a locally made font of 1661 with shields on the bowl and leaves on the shaft, a fine chandelier of c1725 probably made in London, and some medieval tiles bearing the de Bohun swan in the south chapel. There are hatchments of Thomas Wyndham, d1752, and Charles Wyndham, d1801, some fragments of medieval glass, a window of 1898 by Kempe in the chantry chapel by the porch, and a 17th century communion rail.

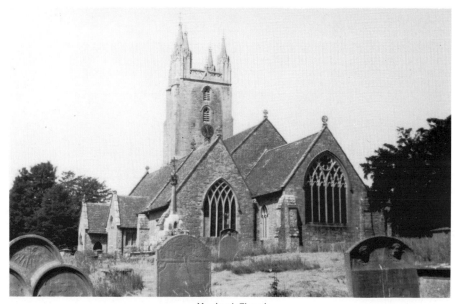

Newland Church

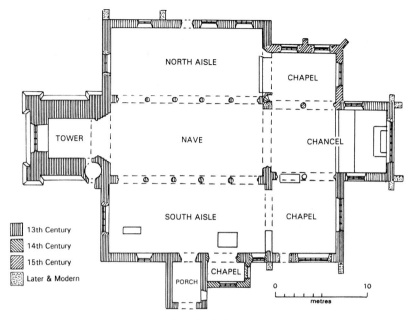

Plan of Newland Church

Newland church contains a fine set of monuments. Effigies of Sir John Joce, c1344, and his wife, d1362, lie on set of a tomb chest in the south aisle. The knight wears armour similar to that of the Black Prince at Canterbury and his head rests on a helm with a head of a Saracen as a crest. The canopied panels on the sides of the tomb are renewed. Under the nave arcades are effigies of Robert de Wakering and of an unknown priest of c1365. The effigy of Jenkin Wyrall, Forester of Fee, d1457, was brought into the church from the graveyard in 1950. An early 17th century forester with a bow, horn, dagger and wide-brimmed hat is depicted on an incised slab in the south aisle. The design may have been partly re-cut at a later date.

On the tomb under the south chapel arcade is an interesting brass. The female figure has an early 16th century style head-dress whilst the male figure has a 16th century style beard on a figure which is clearly mid 15th century, the armour and cropped hair-style being typical of that date. It would seem that his figure was originally that of Robert Gryndour, but it was later appropriated for Sir Christopher Baynham, the female figure then being replaced and the plate with the "miner's brass" then being added. This shows a helmet with mantling and a crest which represents a miner with a hod, pick, and a candle in a holder held in the mouth. This is a very rare instance of a common working man being depicted on a brass. Also within the chapel is a classical style tablet to John Coster, d1719. The chapel by the porch contains a bust by T.Richetts of Sir Edmund Probyn, Lord Chief Baron of the Exchequer, d1742, and other tablets to his family. The north chapel contains a Baroque monument to Benedict Hall of Highmeadow, d1688, and his wife Anne Wynter of Lydney, with the arms of the two families. Under the tower is a Baroque tablet to Christopher Bond, d1688, with laughing cherubs carrying cornucopia.

NEWNHAM *St Peter* SO 691115

Newnham was one of the five ancient boroughs of Gloucestershire. It lay within Westbury parish and had a chapel-of-ease beside the Severn by 1018. The church only attained full parochial status in the 14th century, by which time it was in danger of being undermined by the river. The present church, built on a new site donated by Humphrey de Bohun beside his castle at the south end of the town, was consecrated in 1366. It comprised a nave, south aisle, west tower, north porch and a chancel. In 1644 Colonel Massey captured both the church and castle from the Royalists, but during the commotion the defenders exploded a gunpowder keg in the church, doing some damage and driving all the combatants out.

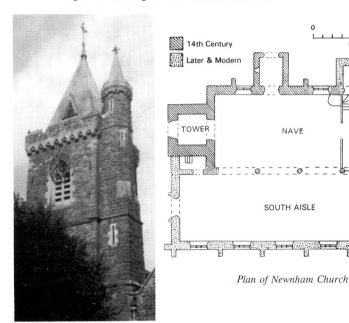

Plan of Newnham Church

Tower at Newnham Church

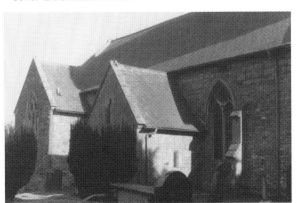

Newnham Church

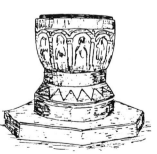

Font at Newnham

The tower was given new battlements in the early 19th century but a new top stage and spirelet were added in 1874, when at a cost of over £4000 the church was rebuilt except for the tower, porch and nave north wall. The aisle was almost doubled in width and a shallow north transept and a south vestry were added. The same architect, Waller, restored the church again in 1881 after a fire which left only the medieval parts intact. Of this period are the reredos and pulpit and the four bay arcade of polished granite piers with foliage capitals. Three 14th century windows containing 19th century glass are reset in the chancel, which has a painted boarded ceiling with bosses and ribs. Relics of a 12th century church on the original site are the font with an arcade of twelve niches containing figures of the Apostles and a fragment of a doorway tympanum carved with a Tree of Life. A chancel arch of the same period or just a little later survived until 1874. There is a brass by Hardman in memory of John Hill, d1894. The mosaic and alabaster St George figure is of 1919.

PARKEND *St Paul* SO 620077

The church lies alone in a forest clearing some distance SE of the town. It was built in 1822 to an unusual but both practical and attractive design by Richard James. It essentially forms an octagon about 15m across with cruciform arms formed by a projecting sanctuary, west end and transepts, all with diagonal corner buttresses. Beyond the sanctuary is a vestry, beyond the transepts are porches, and beyond the west end is an embattled tower with diagonal buttresses rising to pinnacles. The windows are Late Georgian Gothick and the central space has crossing ridge beams and diagonal ribs meeting in a central boss like a rose. The west end contains a gallery. The reredos has a painting of Christ mocked. The altar rails were added by R.W.Patterson during the restoration and redecoration of 1958. There are Royal Arms of George IV. By Cade of Bristol are the monuments to the Reverend Henry Poole, c1857, and John Langham, killed in the Crimean campaign of 1855. See page 30.

PRIMROSE HILL *Holy Trinity* SO 636044

This is a small brick building of 1903 with Romanesque windows. It is hidden away in an estate north of Lydney and is of little interest.

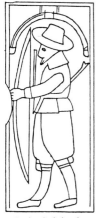

Incised slab of a forester at Newland

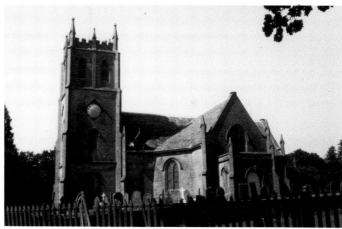

Parkend Church

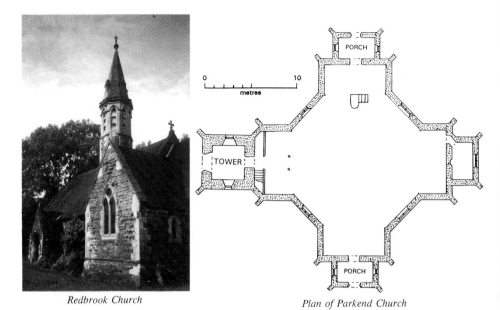

Redbrook Church

Plan of Parkend Church

REDBROOK *St Saviour* SO 537099

This modest church in the style of c1300 perched on a shelf above the Wye was built in 1873 to a design by J.P.Seddon. It has a wide nave and chancel, small transepts, a south porch and a spired turret set between the nave and south transept. Notable features are the sanctuary floor tiles, the choir stalls with carved finials, and the stained glass of 1902 by W.Tower in the east window.

RUARDEAN *St John the Baptist* SO 621177

The church lies on the edge of the forest plateau, commanding a magnificent view to the north and west. It was founded c1110 but the earliest relic is the reset south doorway of c1140 which has a splendid tympanum showing St George on horseback slaying a dragon. It was carved by the Herefordshire team of sculptors who also worked on the churches of Brinsop, Kilpeck, Leominster and Stretton Sugwas. A small carved stone with two fishes discovered in a nearby house in the 1950s was probably also a relic of the church of that era.

In the 13th century the church was given a south aisle with a four bay arcade and a south porch. The piscina in the chancel is also 13th century. The chancel and the aisle west wall appear to have been rebuilt in the 15th century, and most of the rest of the exterior was renewed in 1890 by Waller and Son. The north vestry then added was never completed to its intended size. Of the late 14th century is the diagonally-buttressed west tower with a three-light west window and flying buttresses connecting the corners to a lofty spire.

The plain font is of 1657 and the pulpit is also 17th century. A medieval tomb lies in a recess in the north wall. Tablets in the nave and chancel commemorate Richard Jelfe, d1769, Alice Smith, d1776, John Hankinson, d1637, Charles Bennett, d1829, and Hannah Davis, d1860. The fine set of churchyard monuments have been mostly moved to facilitate grass cutting. Several are propped against the north wall.

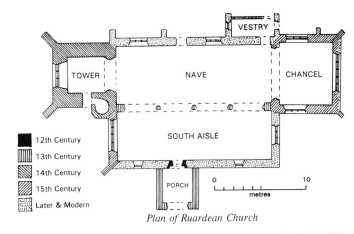

12th Century
13th Century
14th Century
15th Century
Later & Modern

VESTRY

TOWER

NAVE

CHANCEL

SOUTH AISLE

PORCH

0 10

metres

Plan of Ruardean Church

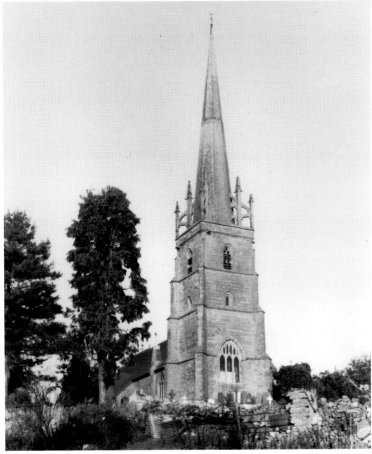

Ruardean Church

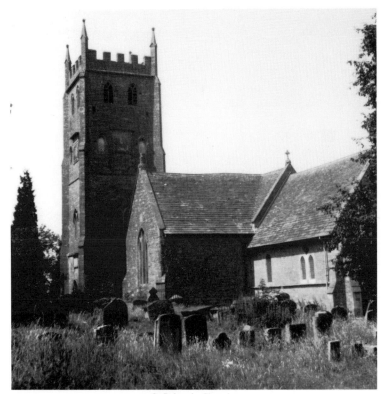

St Briavels Church

ST BRIAVELS *St Mary* SO 558047

There is a Norman narrow south aisle with a five bay arcade of round arches on low circular piers with scallop capitals, small clerestory windows set above the spandrels, and a lean-to roof. Also Norman, but later work of c1180-1200, are the four elaborately moulded arches of the original crossing tower later taken down because it was unsafe and replaced by a south porch-tower of c1830 designed by John Briggs. The north transept masonry may also be of c1200 but the end window is of c1300, when the south transept was rebuilt with diagonal buttresses and an identical window. Of the 13th century is the narrow lean-to north aisle and its four bay arcade. The chancel was also 13th century but was rebuilt in 1861 by J.W.Hugill except for the piscina on the north side. Hugill also provided the north aisle with new windows and buttresses, and added a vestry east of the north transept. Opening from the south aisle are 14th century stairs to the former loft over a now-removed screen.

The Norman font lies on an unusual sixteen lobed shelf. There are Royal Arms of Elizabeth II, an organ of 1922 by Nicholson of Worcester, and the east window glass is of 1899 by Powell. The tomb recess in the south transept contains a slab of to Robert, Abbot of Lire, who died at St Briavels in 1272. It is carved with a cross and, foliage and has a later head fixed upon it. There are also remains of a late 16th century tomb with semi-reclining figures of William Warren and his family, plus a tablet by Woolcott to Charles Court, d1819.

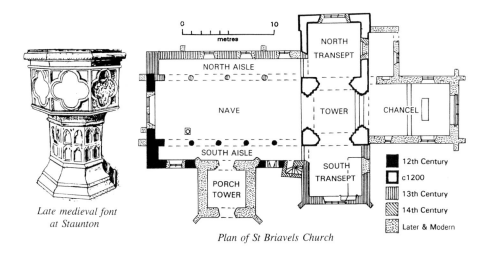

Late medieval font
at Staunton

Plan of St Briavels Church

12th Century
c1200
13th Century
14th Century
Later & Modern

SOUDLEY *St Michael* SO 060106

This rock-faced church of 1910 comprises simply a wide nave with a sanctuary at one end and a porch at the other. The side windows are paired lancets. The east window has glass of 1937 by Wilkinson.

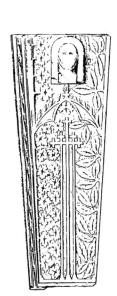

Tomb Slab at St Briavels

Soudley Church

STAUNTON *All Saints* SO 552126

A relic of an 11th century church here is a crude font forming a rough cube with a band of pellet mouldings. The central tower is late 12th century and has original belfry openings and a corbel table. Also 12th century is the north arcade, the three western arches of which are blocked, the aisle having been shortened in the 15th century. The three eastern arches are pointed and must be slightly later than the two round arches further west. The tower arches were renewed in the 13th century, when a larger new chancel was added, along with a south aisle with a five bay arcade and the existing transepts. The blocked arch in the chancel south wall must have led to a chapel, whilst two other blocked arches in the east wall suggest there was once a low vestry beyond. The tower upper stage and battlements are 15th century, but the pinnacles are 19th century. The arms of the Walwyn family appear on an angel on the SW corner. The south aisle was widened in the 14th century to bring the outer wall flush with the transept end wall, and a south porch then added.

The Lady Chapel in the north transept has two 13th century image brackets and a trefoil-headed piscina. An unusual feature is the stone pulpit of c1500 reached by a staircase which also served the former rood loft and then led on up to the belfry. The font in use is also probably of c1500. The chancel east window has stained glass of 1862 and the north transept east window is by Kempe. Medieval glass survives in a tiny upper window in the chancel east wall. In the chancel is a 13th century tombstone with an incised cross and chalice, later reused to form another monument.

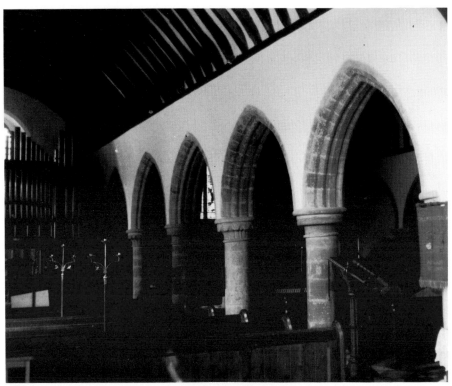

South arcade at Staunton

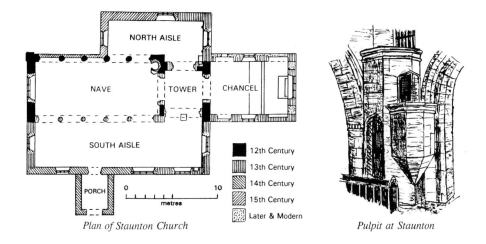

Plan of Staunton Church *Pulpit at Staunton*

STOWE *St Margaret* SO 563063

The north wall of a small medieval chapel is incorporated into the farmbuildings of Stowe Grange, north of St Briavels. The east wall stands ruinously to about 2m high and shows no sign of a window, whilst parts of the other walls stand one metre high.

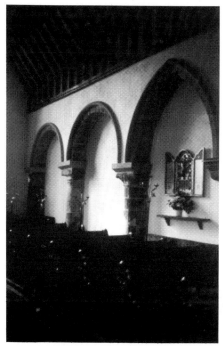

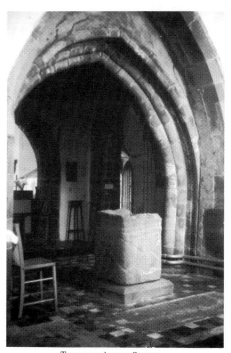

North arcade at Staunton *Tower arches at Staunton*

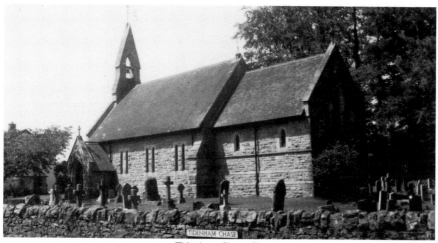

Tidenham Chase Church

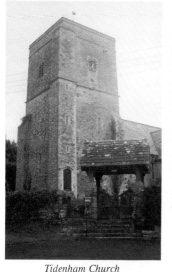

Tidenham Church

TIDENHAM *St Mary* ST 556958

Although mentioned in Domesday Book, the oldest part of this church is the early 13th century west tower with lancet windows and clasping buttresses. The equally plain upper part of the tower was added in the 15th century to serve as a beacon for navigation in the Severn estuary far below. Also 13th century are the nave and chancel with a fine shafted doorway and clasping east buttresses. The wide north aisle with three arches on quatrefoil-shaped piers without capitals towards the nave and one arch towards the chancel was added c1290-1310. The ogival-headed south windows are of c1340. One contains pieces of old glass. The church was much restored in 1858 by John Norton.

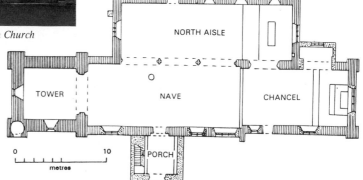

Plan of Tidenham Church

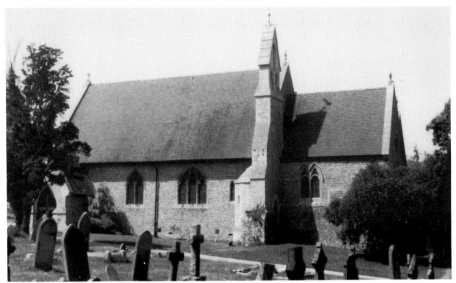

Tutshill Church

Tidenham church contains a lead font which was cast from the same mould as that which once lay in Lancaut church not far away. There is glass by Geoffrey Webb in the east window. The numerous 19th century tablets include those to Sarah Lowder, d1802, Selwyn Jones, d1805, Anna Camplin, d1812, Frances Morgan, d1831, and Drummond Thatcher, d1835.

TIDENHAM CHASE *St Michael* SO 556988

This church lies almost alone in a clearing beside the B4228 3km north of the medieval church of Tidenham. It comprises a rock-faced nave, chancel, south porch and a bellcote on the west wall. It was built in 1888 to a design by S.Gambier-Parry and has lancets in ones, twos and threes. Inside is a reredos with mosaics and there is contemporary glass in the pre-Raphaelite style in the east window.

TUTSHILL *St Luke* ST 540095

Tutshill lies by the mouth of the Wye opposite Chepstow. It became fashionable in the early 19th century and in 1853 gained its own church designed by Henry Woodyer. The building comprises a nave and north aisle separated by an arcade copied from that at nearby Tidenham, a chancel with a two bay arcade to a north vestry and organ chamber, a south porch, and a bellcote raised on a massive buttress on the south side of the chancel arch, with a projection adjoining with contains a staircase up to the pulpit. The contemporary glass in the east window is probably by O'Connor. The north window glass is of c1894.

VINEY HILL *All Saints* SO 655066

This church of local sandstone with an apsidal sanctuary was built in 1867 to a design by Ewan Christian. It has a south aisle with a roof continuous with that over the nave, but with a break of slope, and a south porch and a non-projecting transept.

13th Century
14th Century
15th Century
16th Century
Later & Modern

0 10 20
metres

Westbury Church

Plan of Westbury Church

WESTBURY-ON-SEVERN *St Peter, St Paul and St Mary* SO 717139

Although much restored by Medland and Maberly in 1862 and 1878, when the southern vestries were added, the church is almost all of c1300. It comprises a long aisled nave with a north porch and a chancel. The seven bay arcades have alternating octagonal and quatrefoil shaped piers. The chancel has a rose-piscina but no other ancient features. The west wall contains a canopied niche containing a Calvary and a later medieval window. An inscription in a south aisle window "This church, built in AD 1530, was dedicated to the Virgin Mary", refers only to a minor remodelling and the addition of a porch with a Tudor outer arch on this side. There is a 19th century font and another dated 1583 with the arms of Elizabeth I. Some of the pew bench ends have linenfold panels typical of c1520. There are two chandeliers of c1730, probably from Bristol. The chancel windows have glass of the 1860s, and a north aisle window has glass of 1906. In the chancel are many tablets to the families of Wintle, Boughton and Colchester.

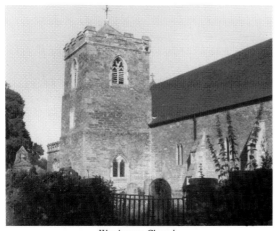

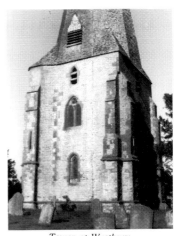

Woolaston Church *Tower at Westbury*

Some 15m beyond the north porch is the detached bell tower of c1270, a massively walled and heavily buttressed structure almost 9m square externally. The tower was used as a strongpoint in 1644 by a party of Royalists based at a nearby fortified house, but both places were soon captured by Colonel Massey. Upon the tower is a 14th century wooden-framed broach spire 45m high which has been rebuilt several times and was last recovered with wooden shingles held with copper nails in 1937. The arch and roof marks on the east face are relics of the 14th century chantry chapel of St Mary, later used as a school, but dismantled in 1862.

Westbury-on-Severn was originally an unusually large parish and required several chapels-of-ease, one of which, Newnham, later attained full parochial status. The other chapels seem to have fallen out of use by the 16th century and none of them survive. In 1840 it was reported that three new chapels and attendant clergy were urgently needed. A brick mission chapel dedicated to St Luke was eventually built at Chaxhill, and in 1908 and 1916 others were constructed at Rodley and Northwood.

WOOLASTON *St Andrew* ST 587994

The church is first mentioned in 1131, and the long nave may have some Norman masonry, although the restored windows are of c1300. By the end of the 13th century the church had become cruciform with a north transeptal tower and a south transeptal chapel. The tower was rebuilt in the early 19th century and embattled in 1840. Between it and the heavily restored chancel is a vestry added in 1903. The chapel was absorbed into a south aisle built in 1829 by John Briggs, but was furnished as a chapel again in 1954. The arcade has polished granite columns with foliage capitals. The aisle was later given transverse gables, perhaps in 1859 when the large porch west of it was rebuilt. The nave roof, the font, and the former priest's doorway now set up as a gateway facing the vicarage are all 14th century. there is a mutilated medieval panel depicting the Crucifixion. The pulpit of c1750 was brought over from Claycoton in Northamptonshire in 1966, and the screen has come from the Church of the Venerable Bede at Sunderland. There are 19th century monuments to several members of the Hammond and Woodroffe families, and a tablet in a neo-Greek style to John Powles, d1844.

Nothing now remains of a medieval chapel with a vaulted undercroft at Woolaston Grange, 1km south of the parish church.

GLOSSARY OF TERMS

Baroque	- A whimsical, odd form of the Classical style.
Beakhead	- Decorative motif of bird or beast heads.
Calvary	- Crucifixion scene, sometimes with three crosses.
Chamfer	- A slope made by cutting off a right-angled edge.
Chancel	- The eastern part of a church used by the clergy.
Chapel-of-ease	- Chapel administered from and by a parish church.
Clerestory	- The upper storey of a church, with windows.
Collar-Beam	- Tie-beam used higher up, nearer the roof apex.
Cummunion Rail	- A wooden rail around or in front of an altar.
Cruciform Church	- A cross-shaped church with transepts.
Dado	- Decorative covering of lower part of a screen.
Dressings	- The cut stones used for openings and corners.
Embrasure	- An opening through the thickness of a wall.
Flamboyant	- Late medieval French architectural style.
Four-Centred-Arch	- Arch with curves drawn from four compass points.
Gothick	- Imitation late mèdieval style of c1740 - 1830.
Hoodmould	- Moulding over an arch to throw off rainwater.
Jamb	- The side of a doorway, window, or other opening.
King-Post	- Upright post connecting a tie-beam and collar-beam.
Lancet	- Long narrow single light window with pointed head.
Light	- A conpartment of a window.
Linenfold Panel	- Panel with representation of linen in vertical folds.
Nave	- The part of a church used by the congregation.
Norman	- English architectural style from 1066 to c1200.
Piscina	- Stone basin for rising out vessels after mass.
Plate-Tracery	- Massive, elementary tracery, current c1260-90.
Pre-Raphaelite	- Victorian imitation of late medieval painting style.
Rebate	- Rectangular notch cut in a jamb to take a door.
Reredos	- A structure behind an altar.
Respond	- A half-pier or half column bonded into a wall.
Roll-Moulding	- A moulding in the form of a continuous roll.
Spandrel	- Surface between arches or between an arch and corner.
Tie-Beam	- Beam connecting roof slopes near their foot.
Tracery	- Intersecting ribwork in the head of a window.
Transept	- Projecting arm of a church containing an altar.
Tympanum	- Space between a doorway lintel and an arch above.
Victorian	- The time of Queen Victoria (1837-1901).
Wind Braces	- The struts strengthening the slopes of a roof.

FURTHER READING

The Forest of Dean, Humphrey Phelps, 1982.
The Victoria County History of Gloucestershire.
Transactions of the Bristol & Gloucestershire Archeological Society.
Gloucestershire: The Vale and the Forest of Dean, David Verey, 1970
 (Buildings of England series).